Contains:

7 Lovely Words

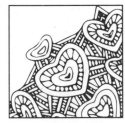

6 Heart Mandalas

2 LOVE Typography

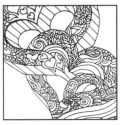

5 Heart Shapes

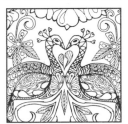

2 Animals

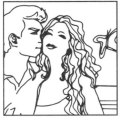

1 Couple

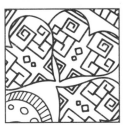

7 Designs & Doodles

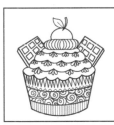

2 Sweet Delights

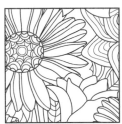

6 Flowers

WAMA
COLORING BOOK

image on page 37: julisnegi/Fotolia.
Images on pages 5,6,9,11,13,15,16, 22, 25, 30,
32, 35, 38 and 40, used under license
from Shutterstock.com.

GANZ™
™ GANZ, Woodstock, GA 30188
ganz.com

Printed in China
978-0-9970517-2-8

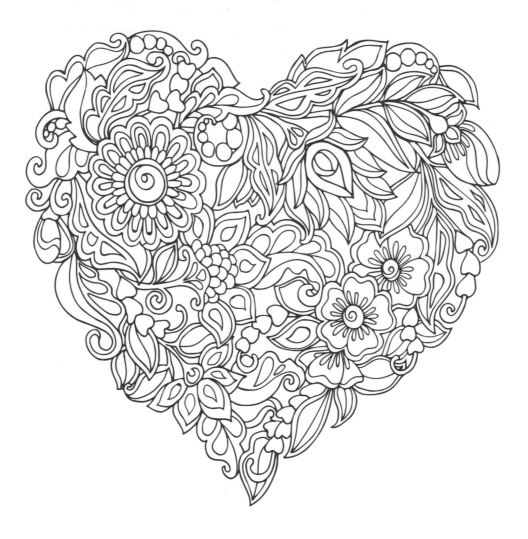

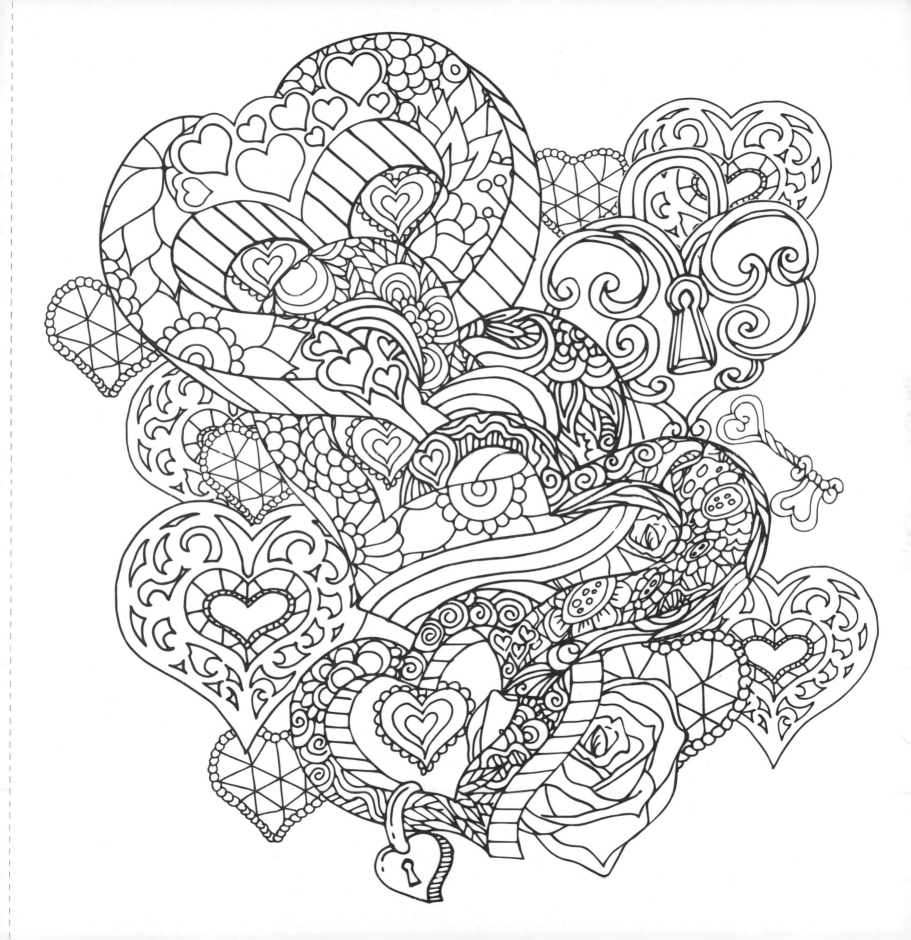

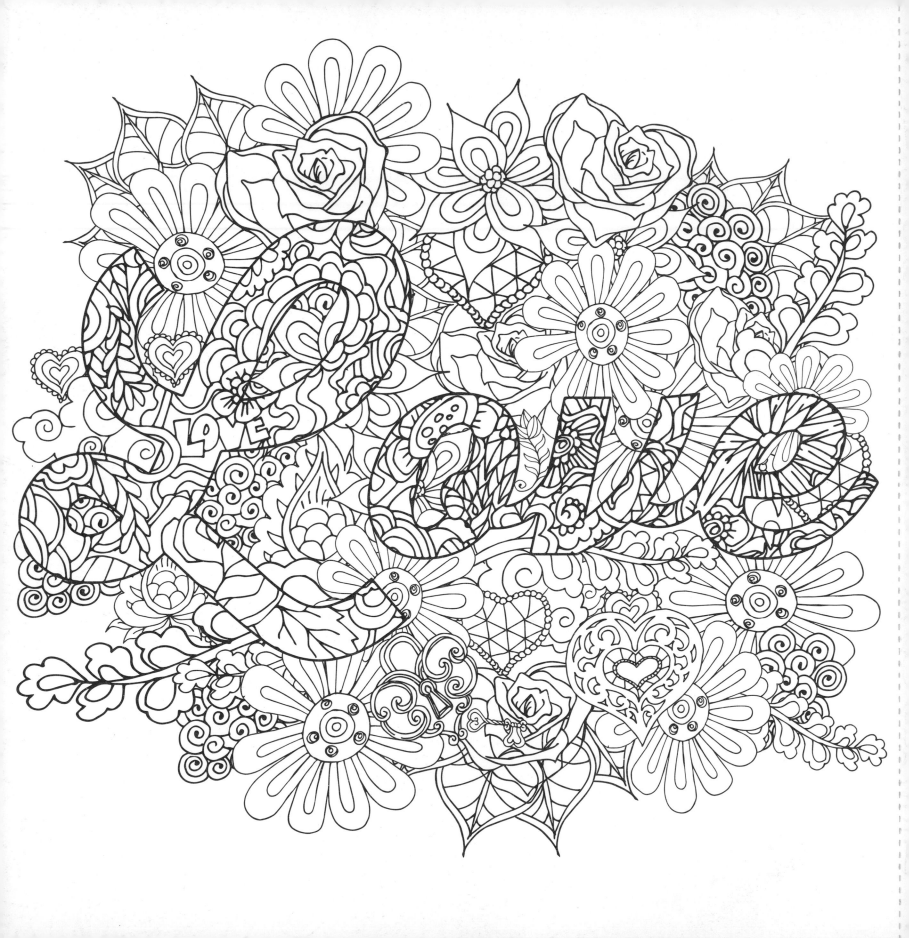

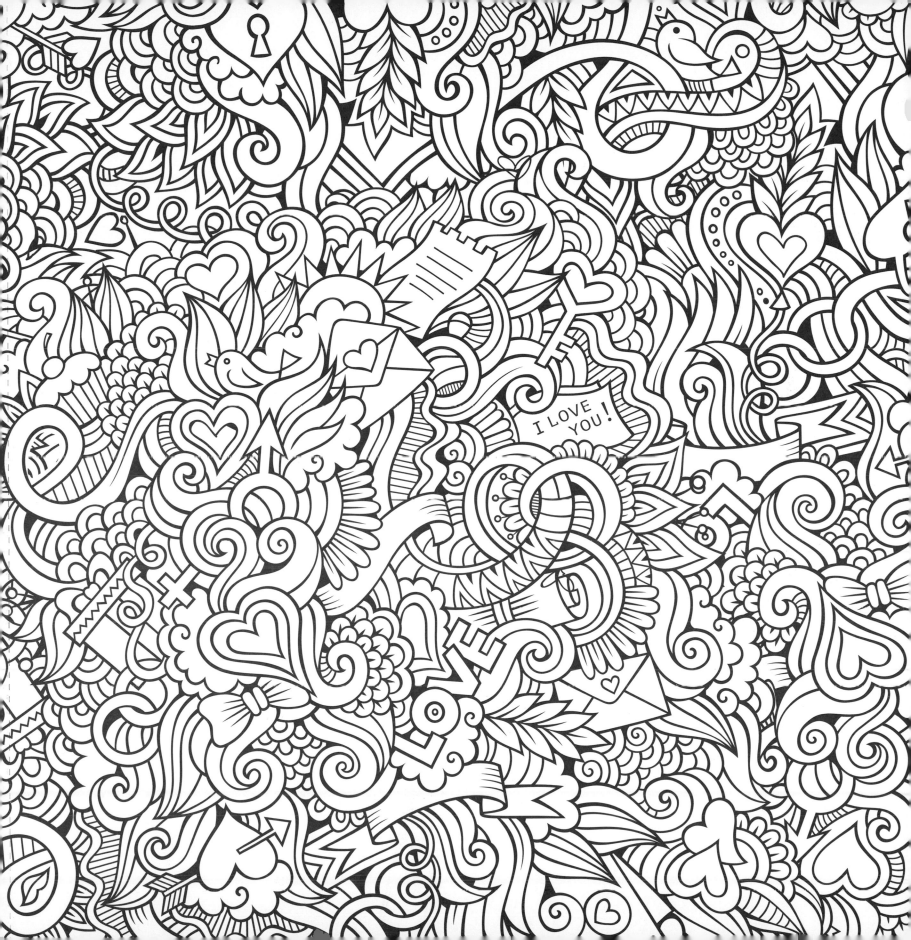

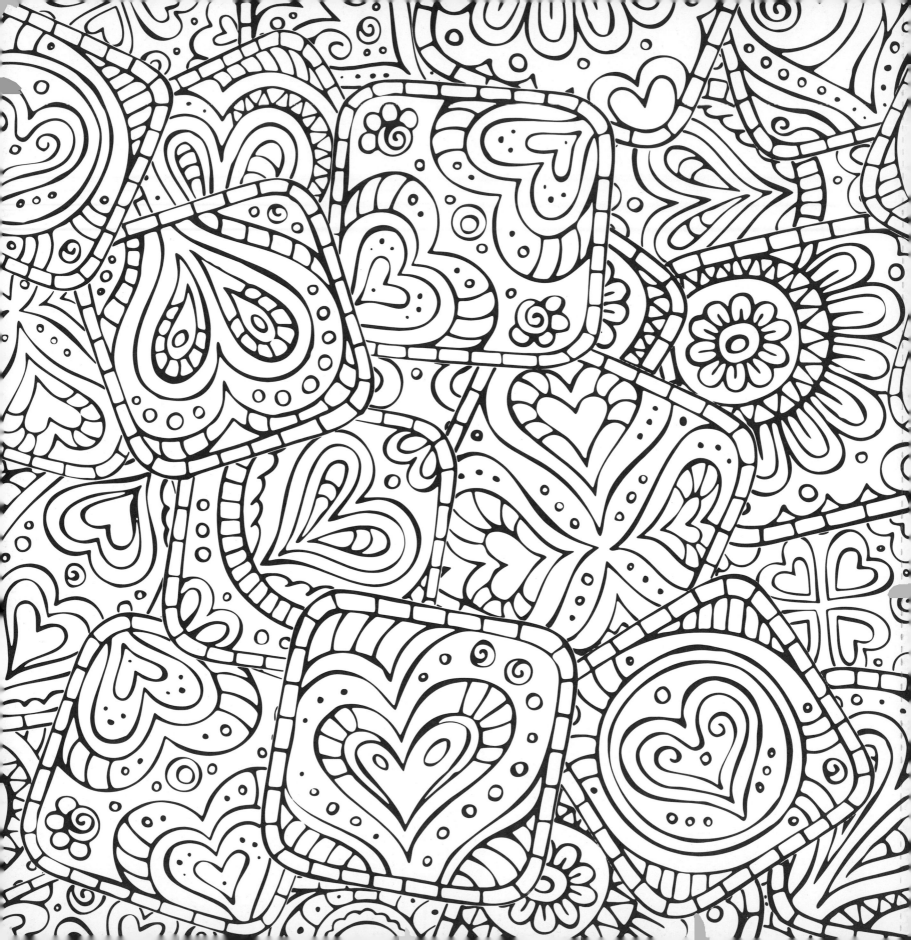

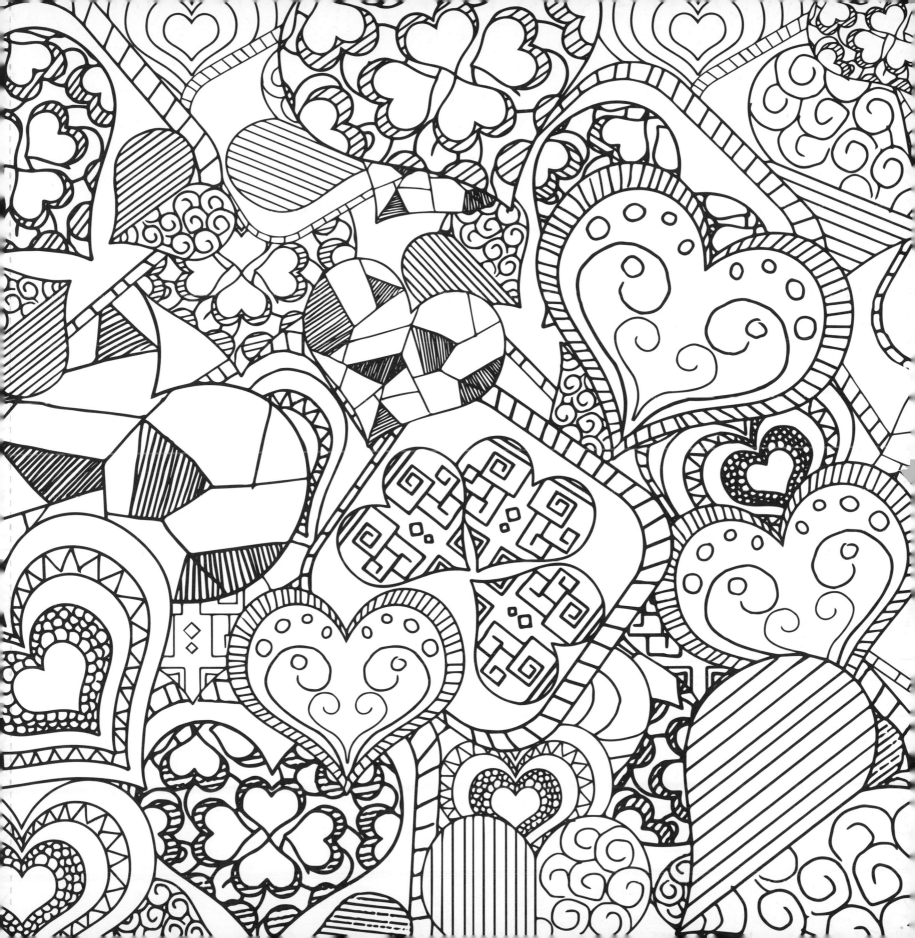

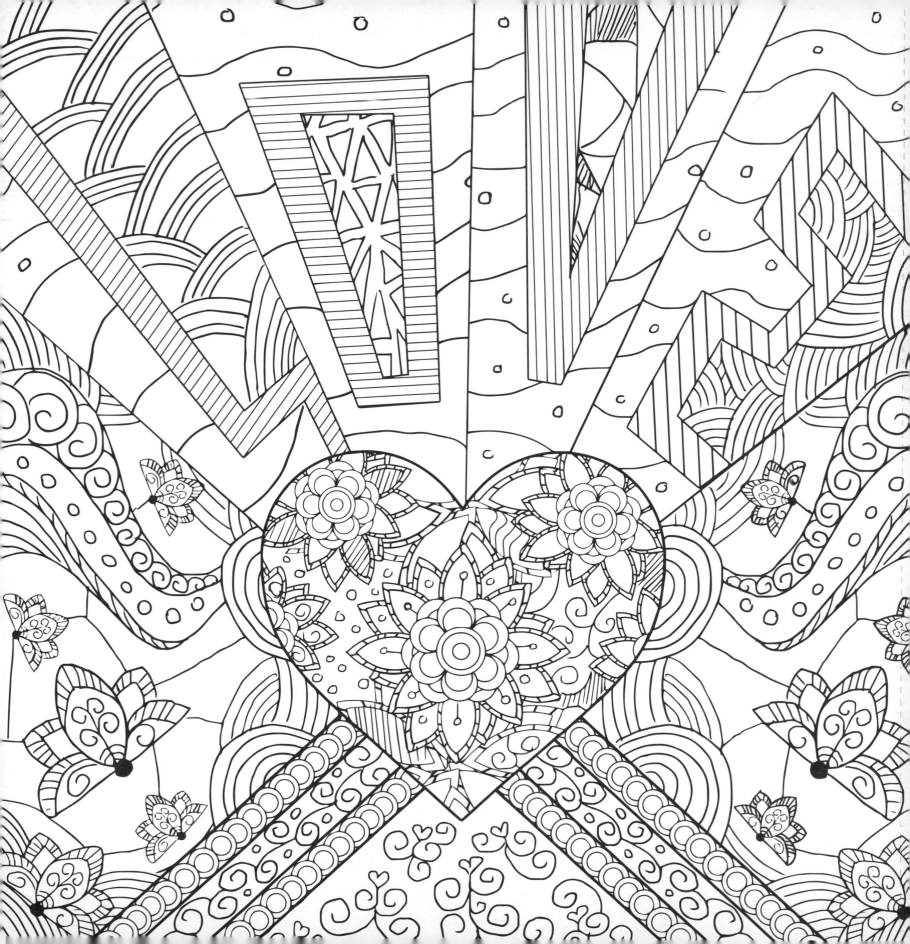

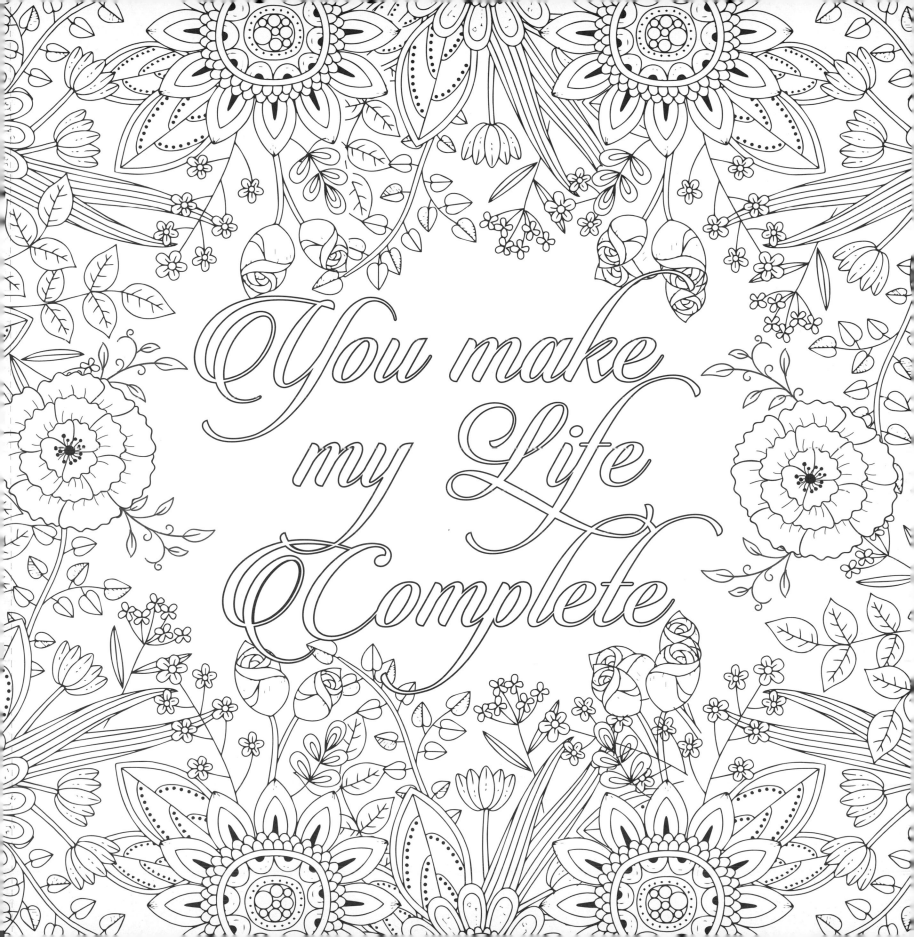

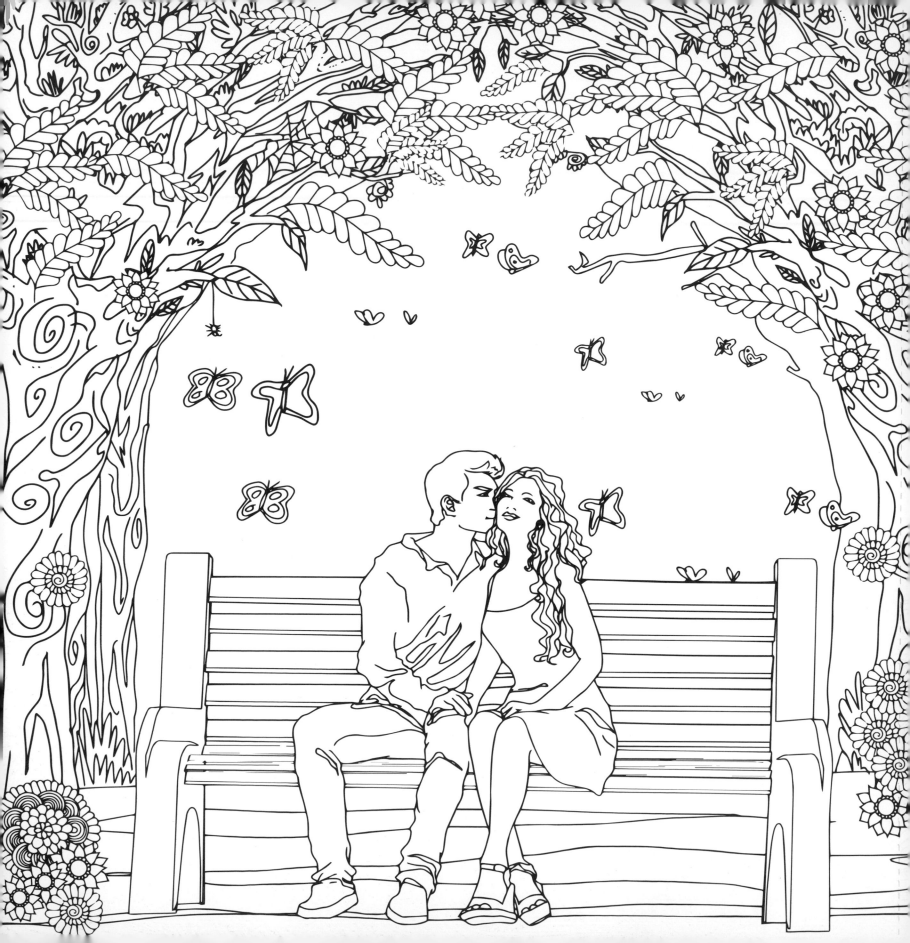

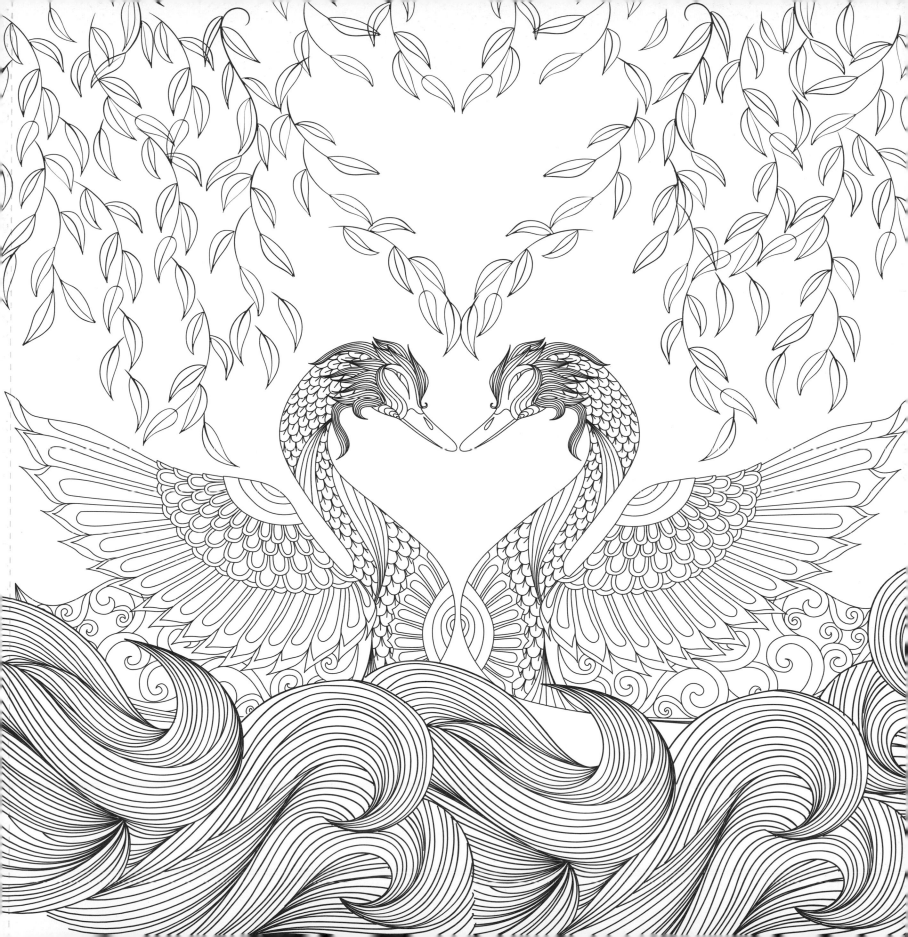

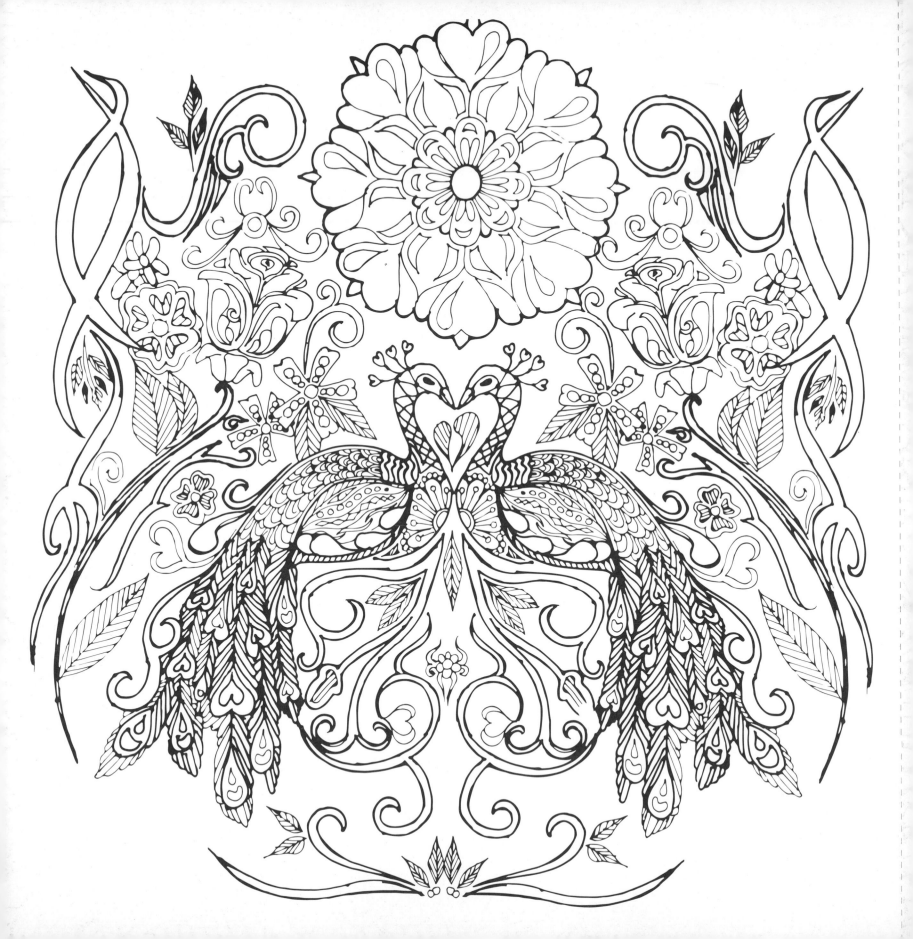

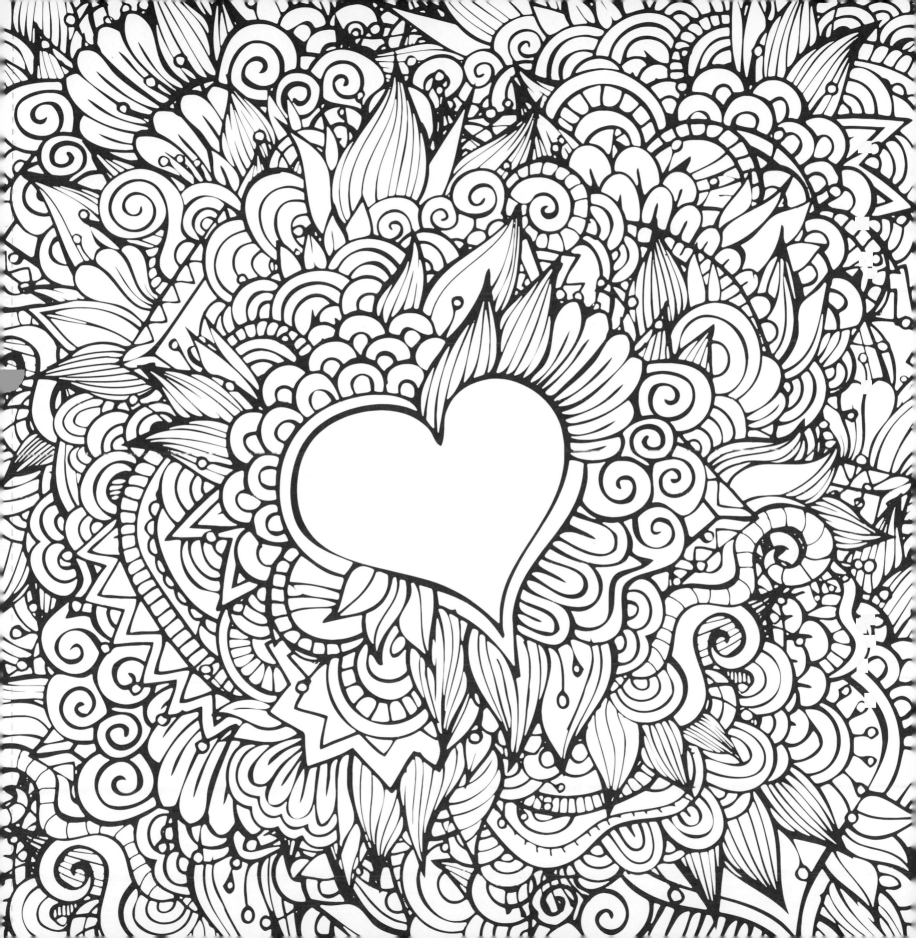

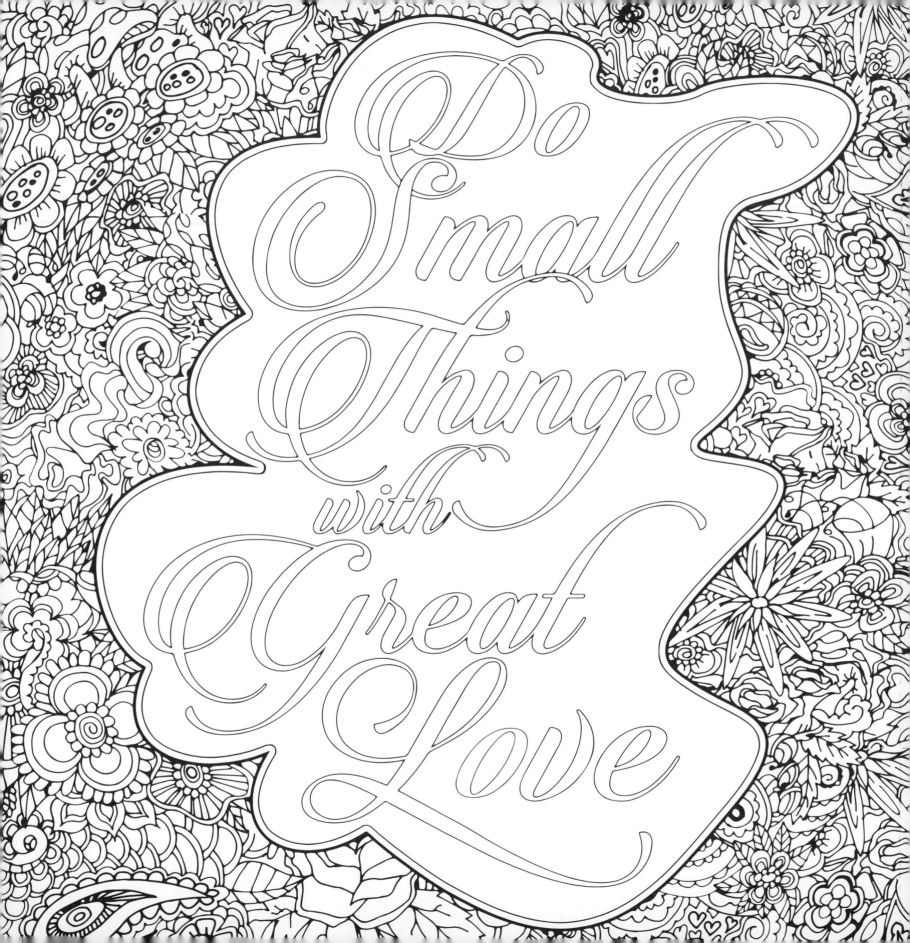

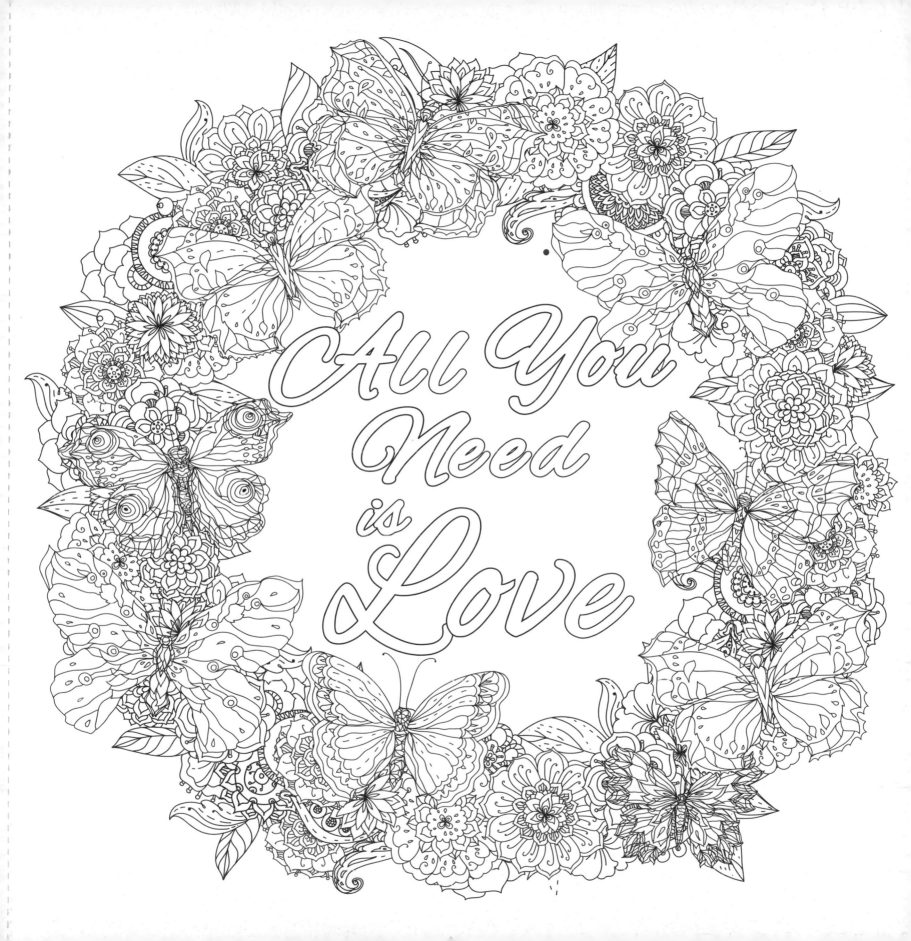

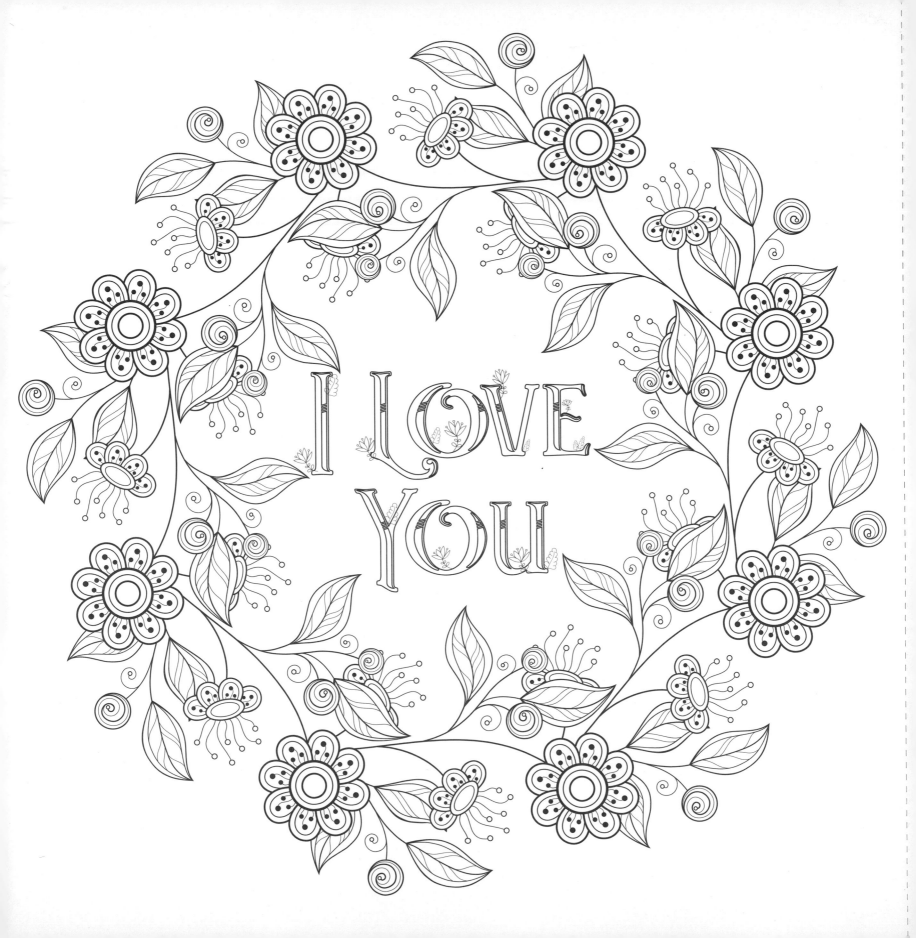

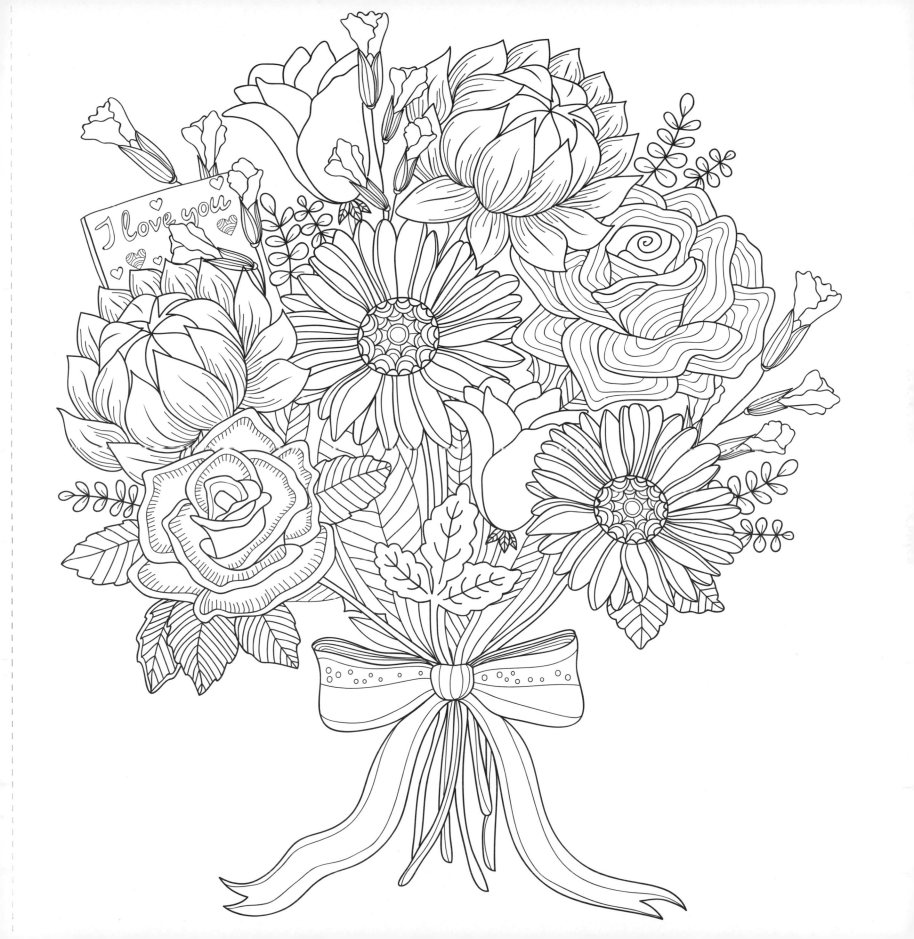

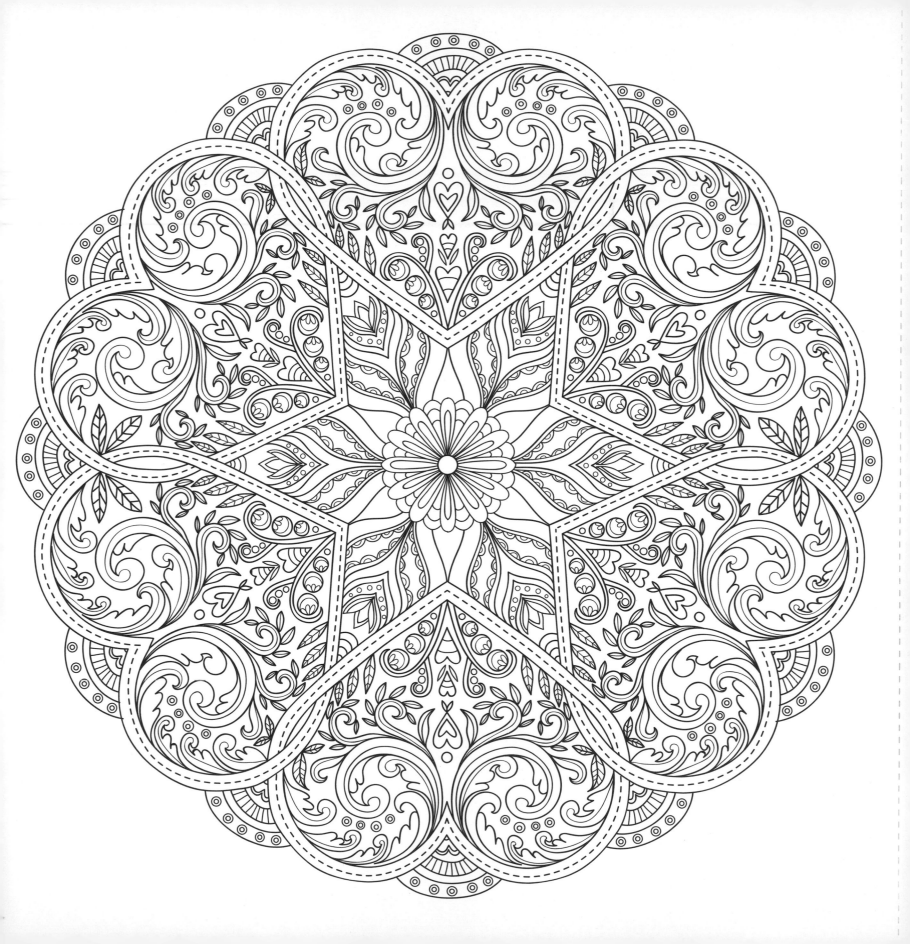

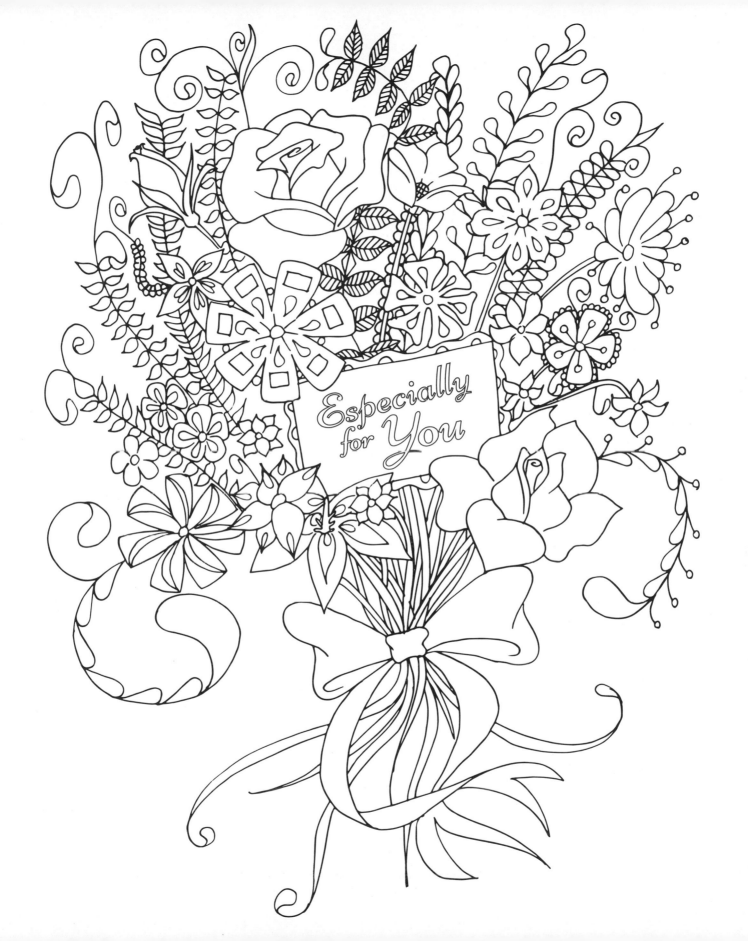

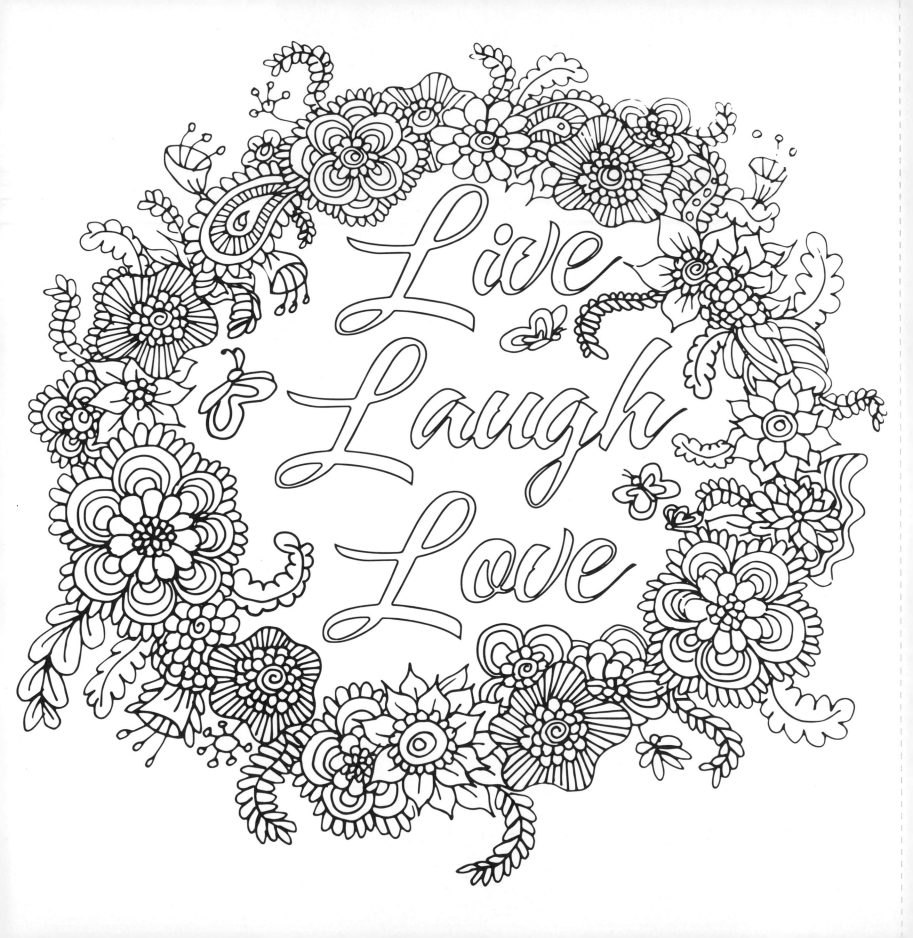

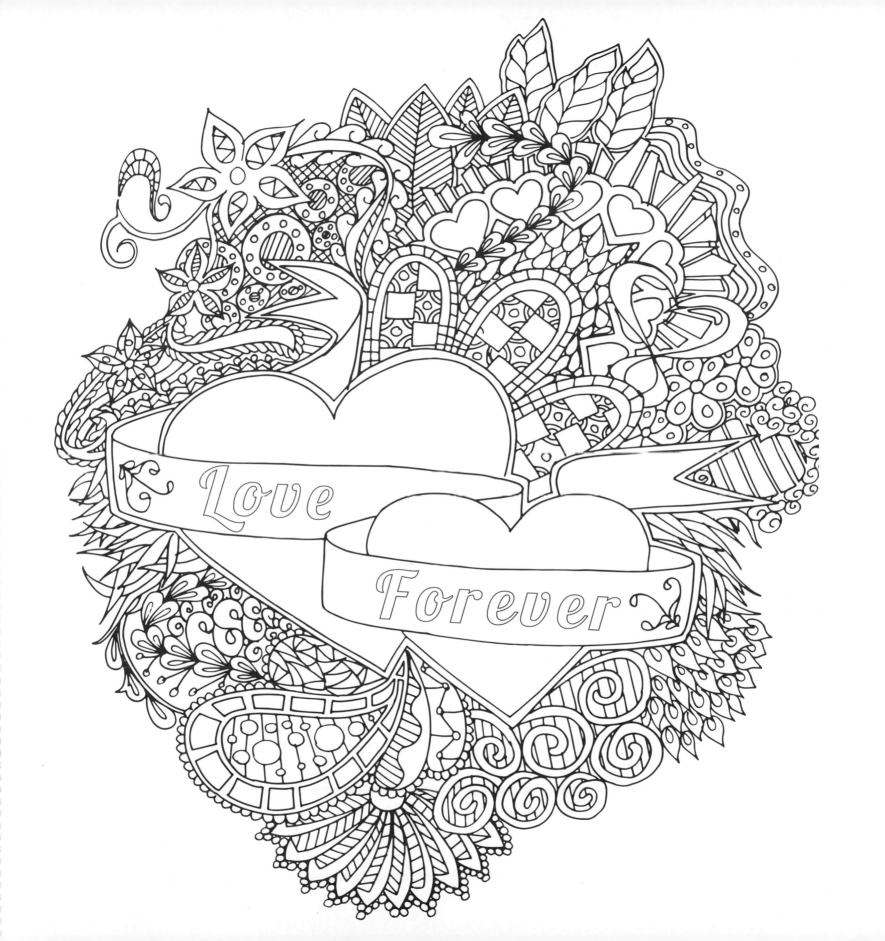

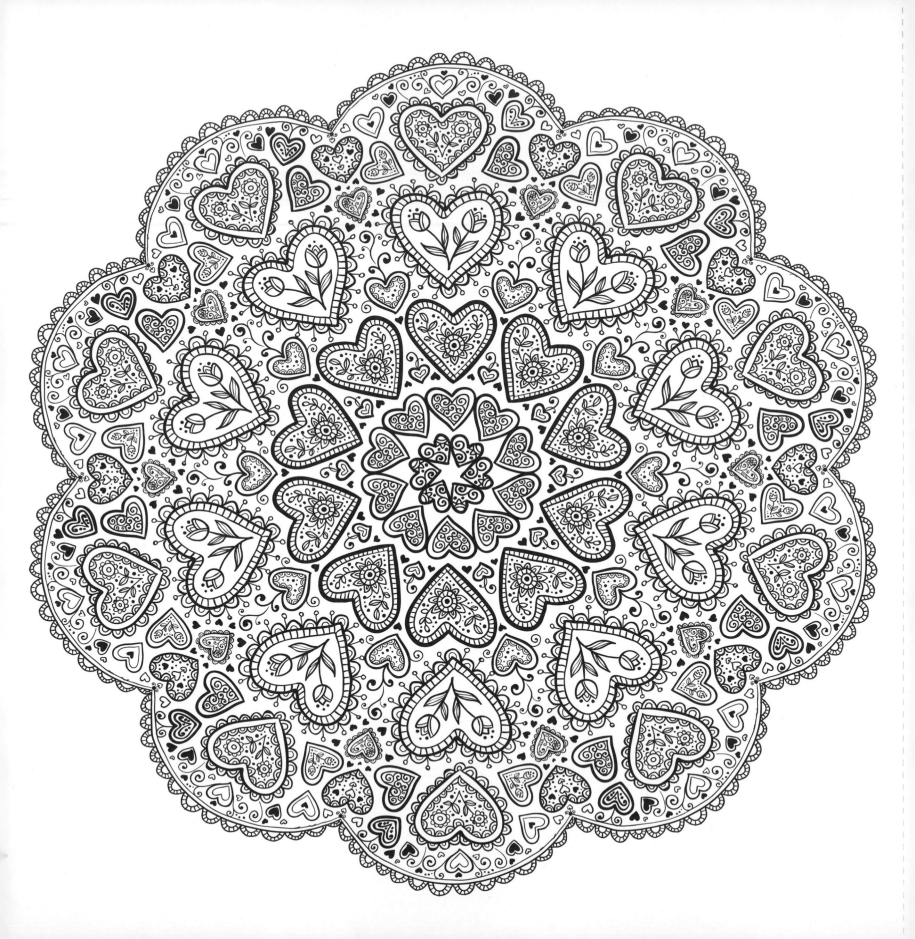

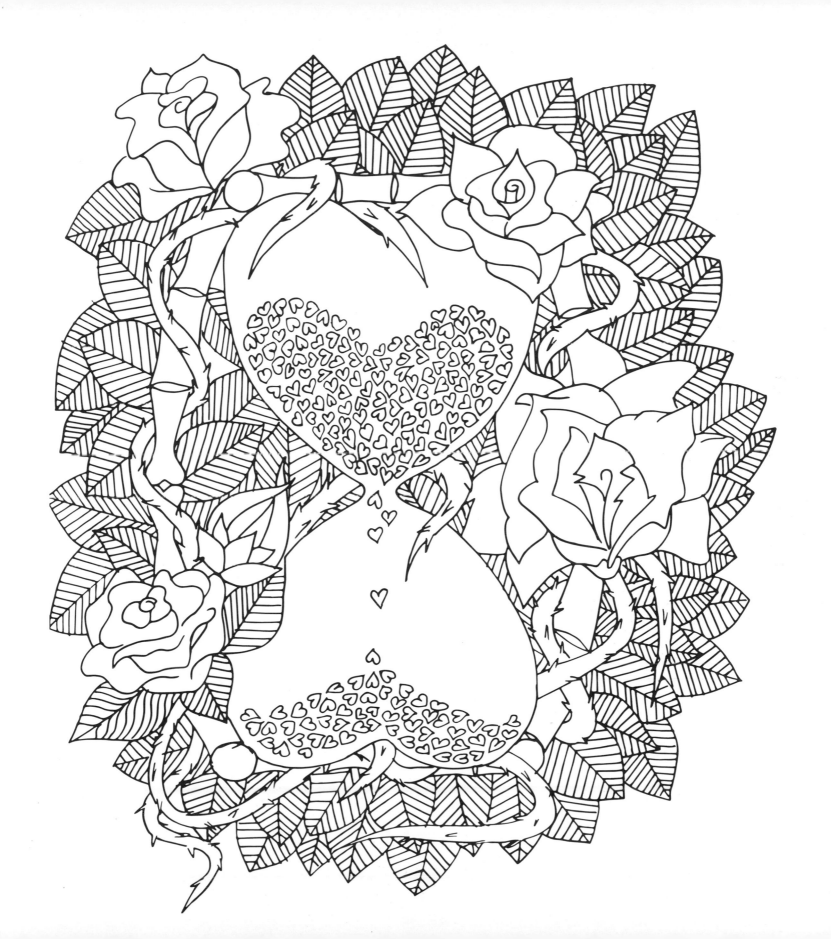

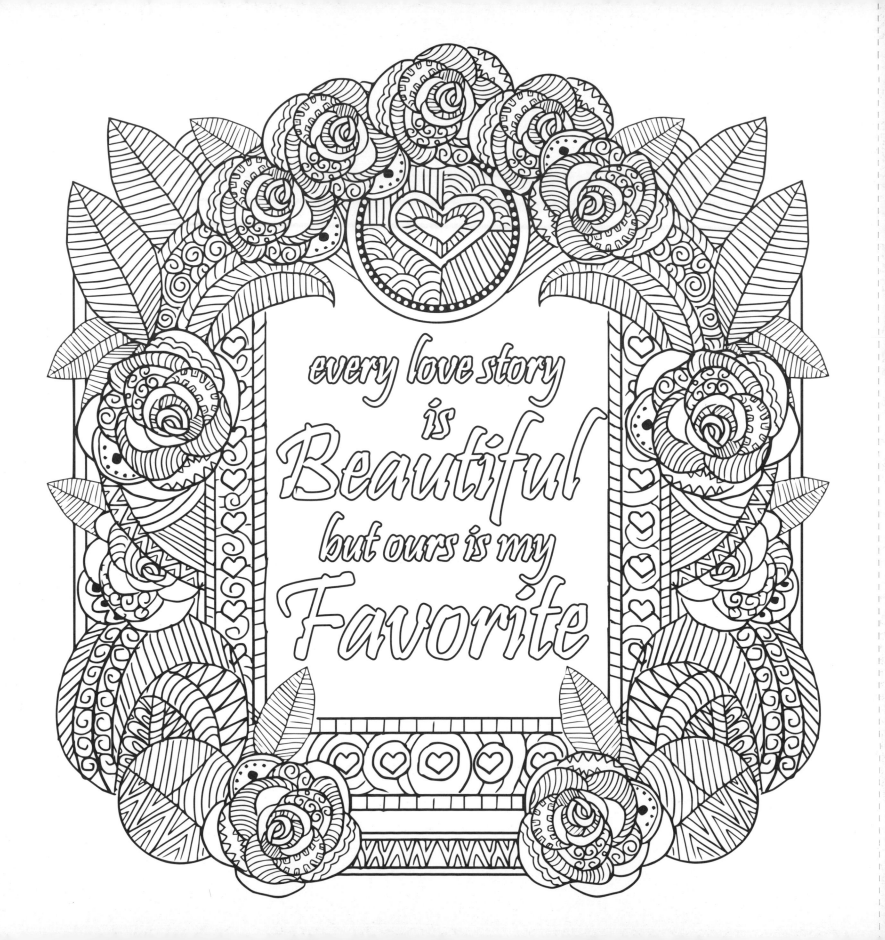

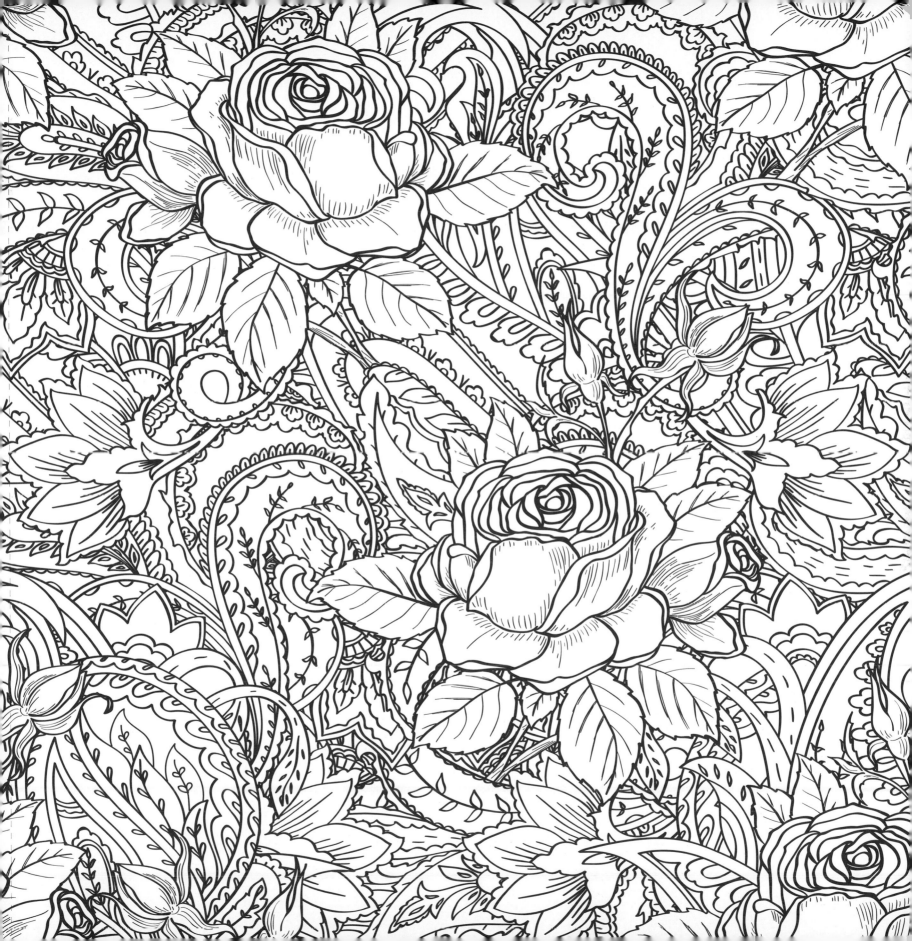

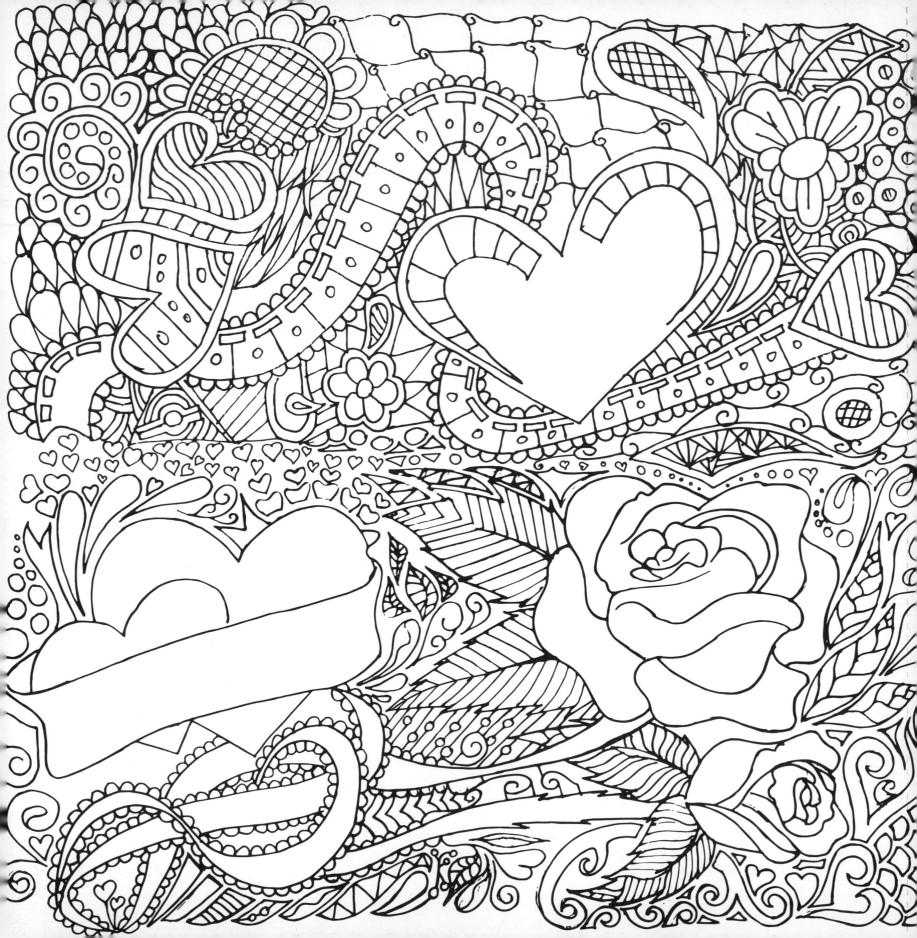

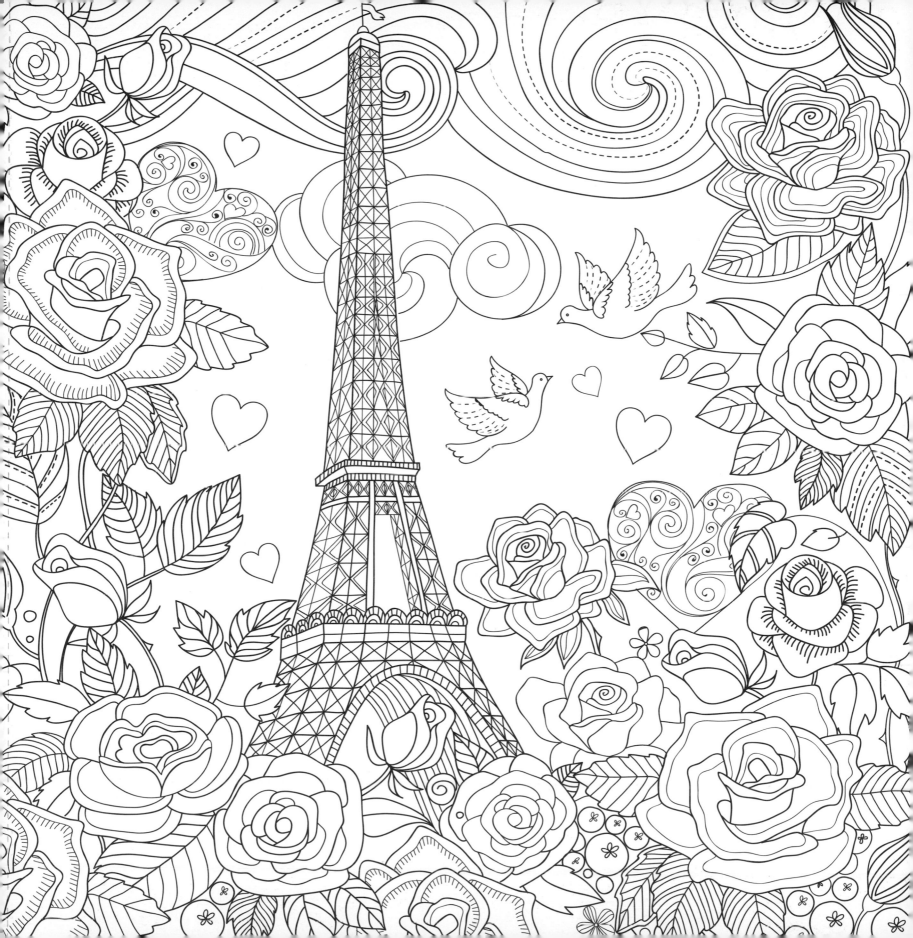

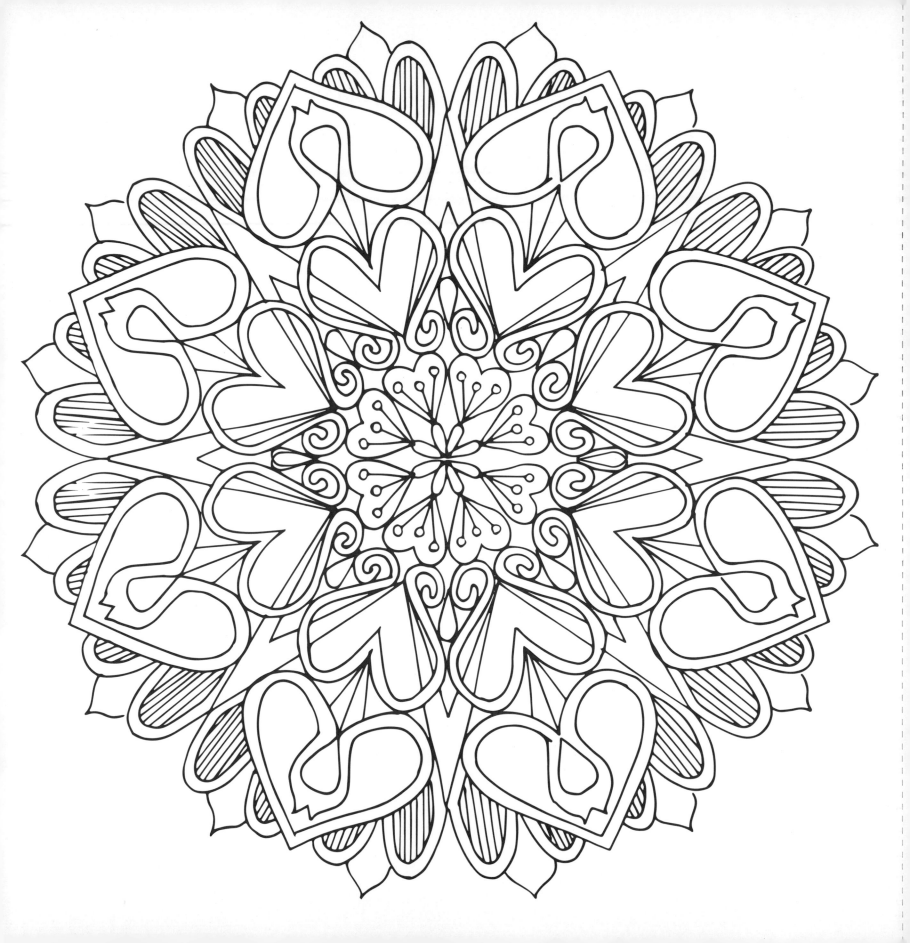

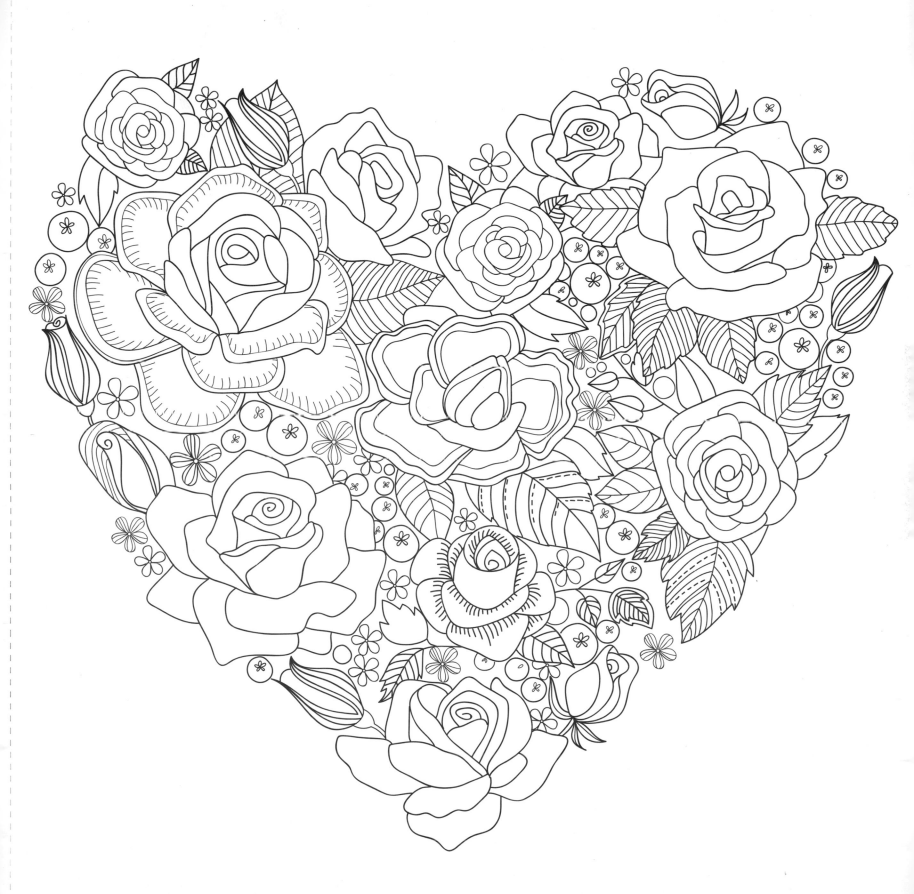

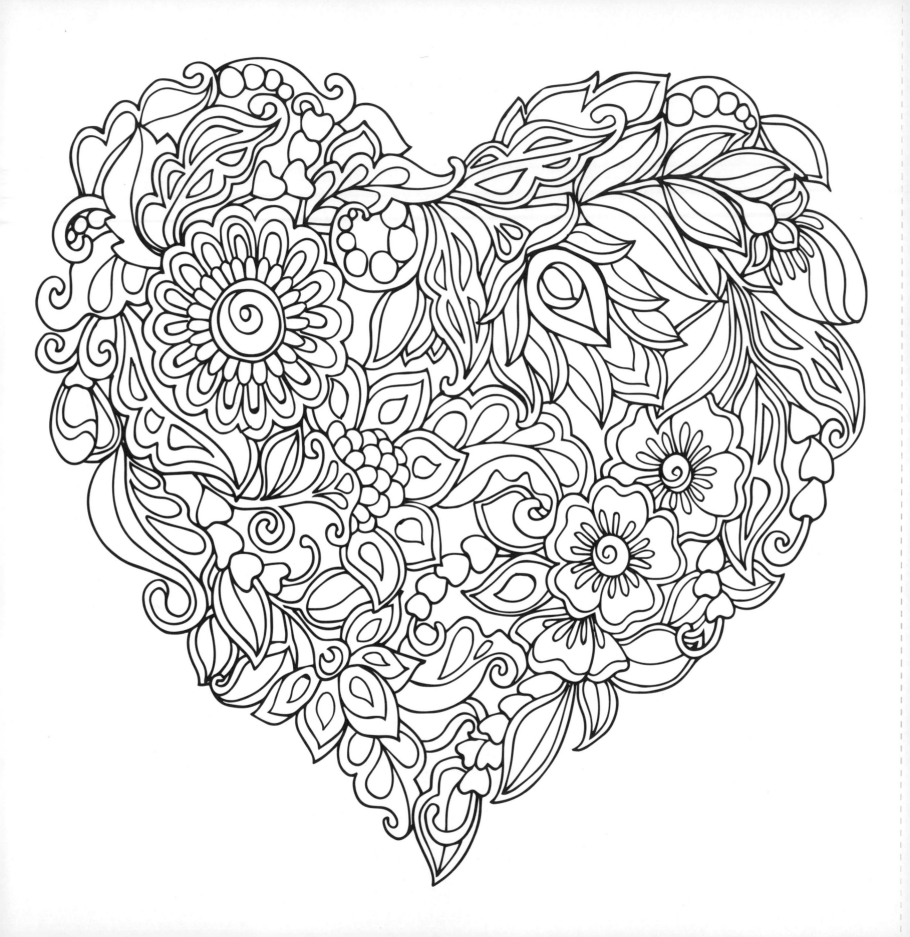

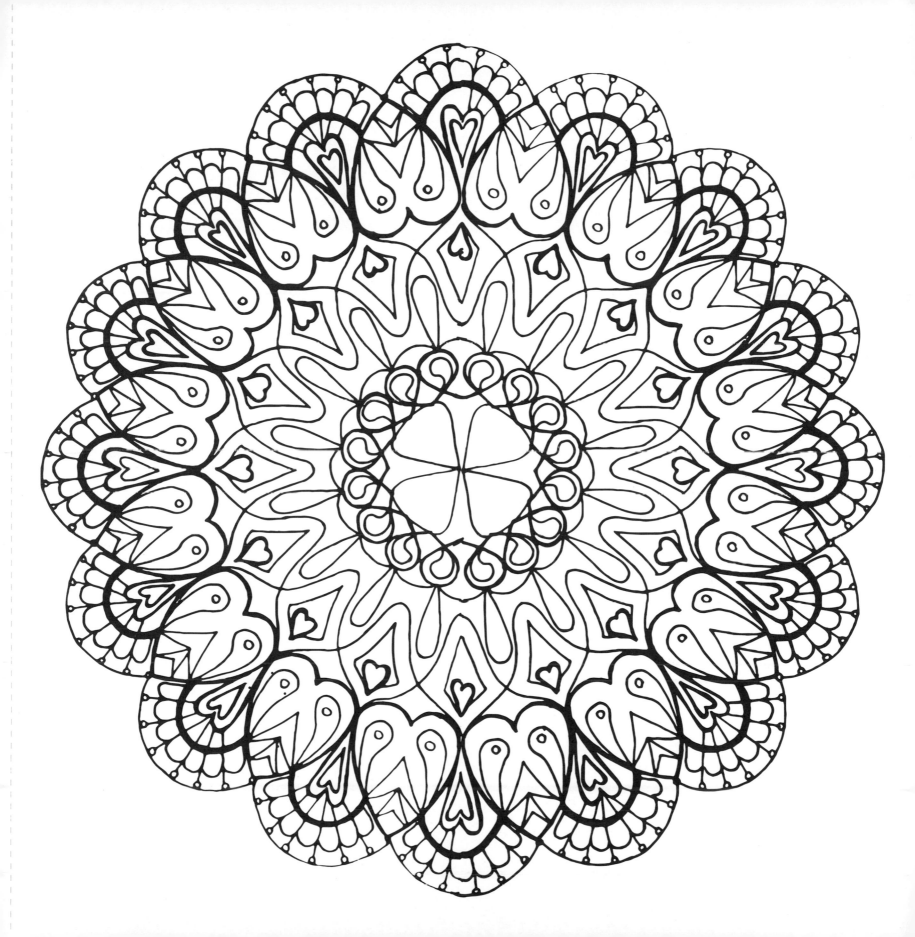

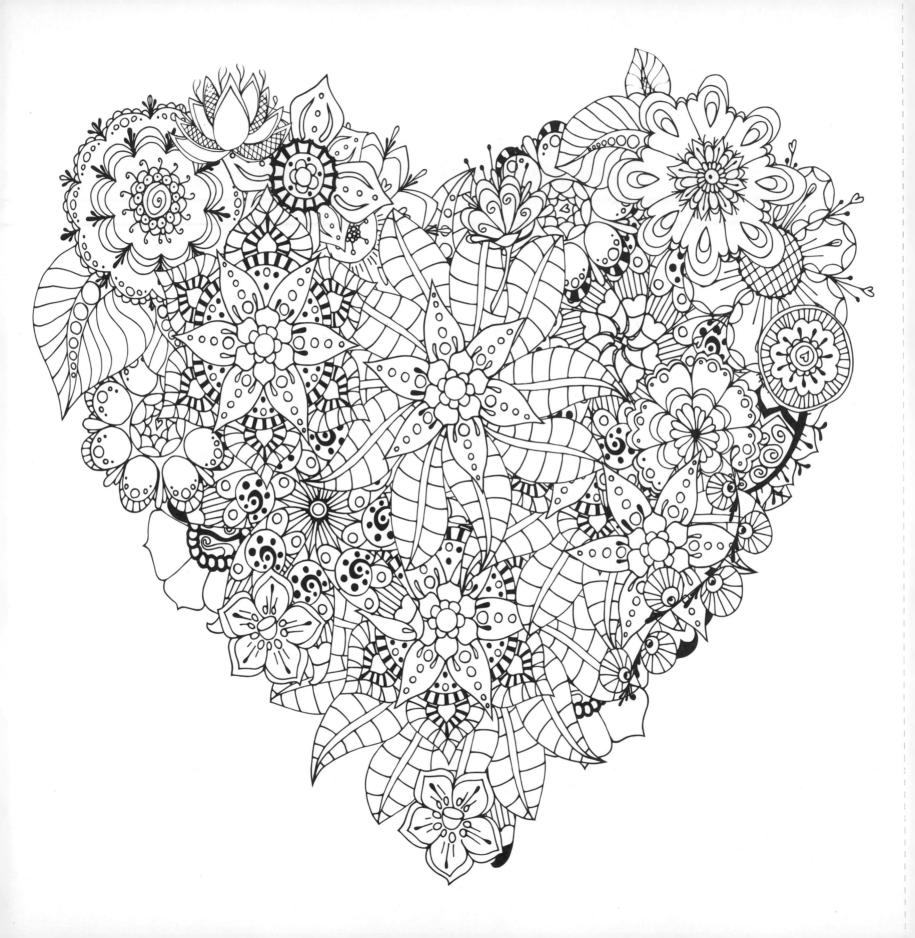

I Love You
with
All My Heart

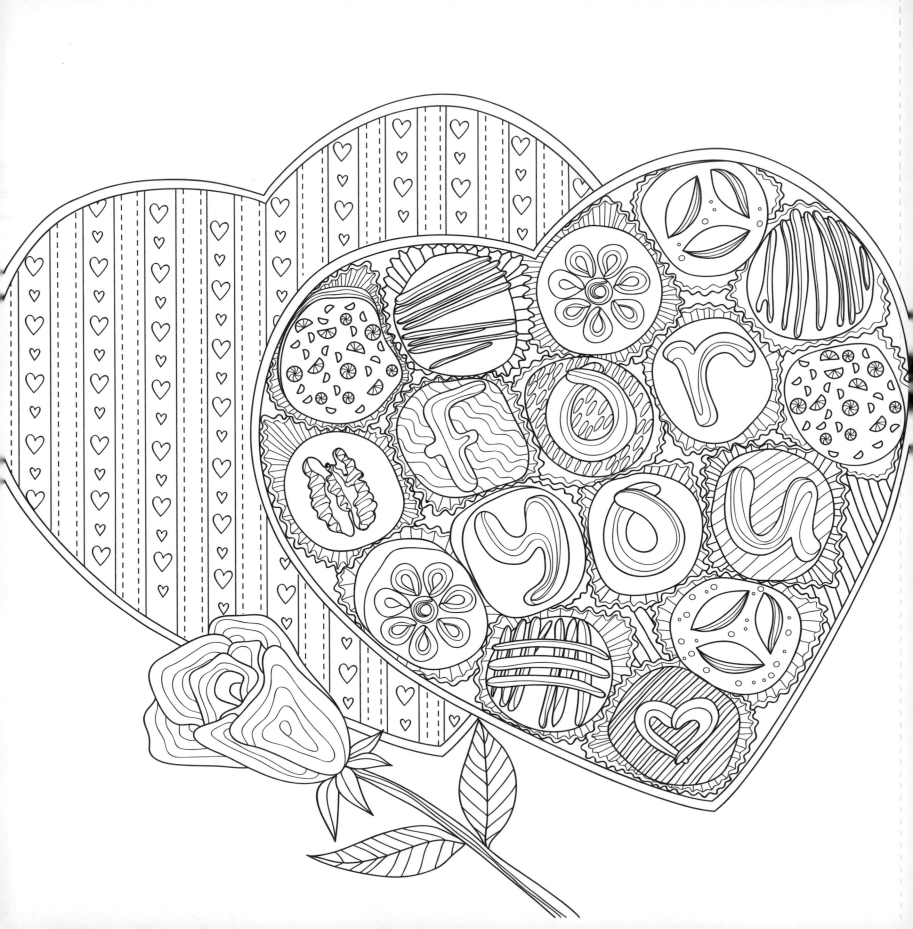

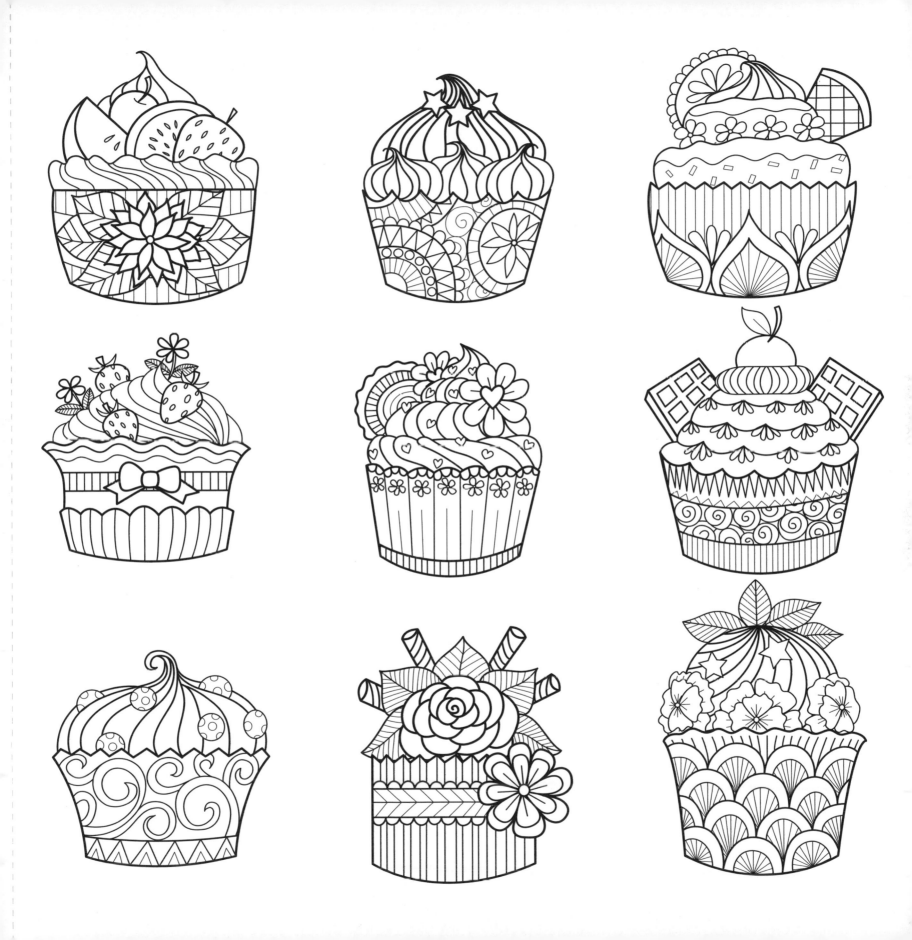

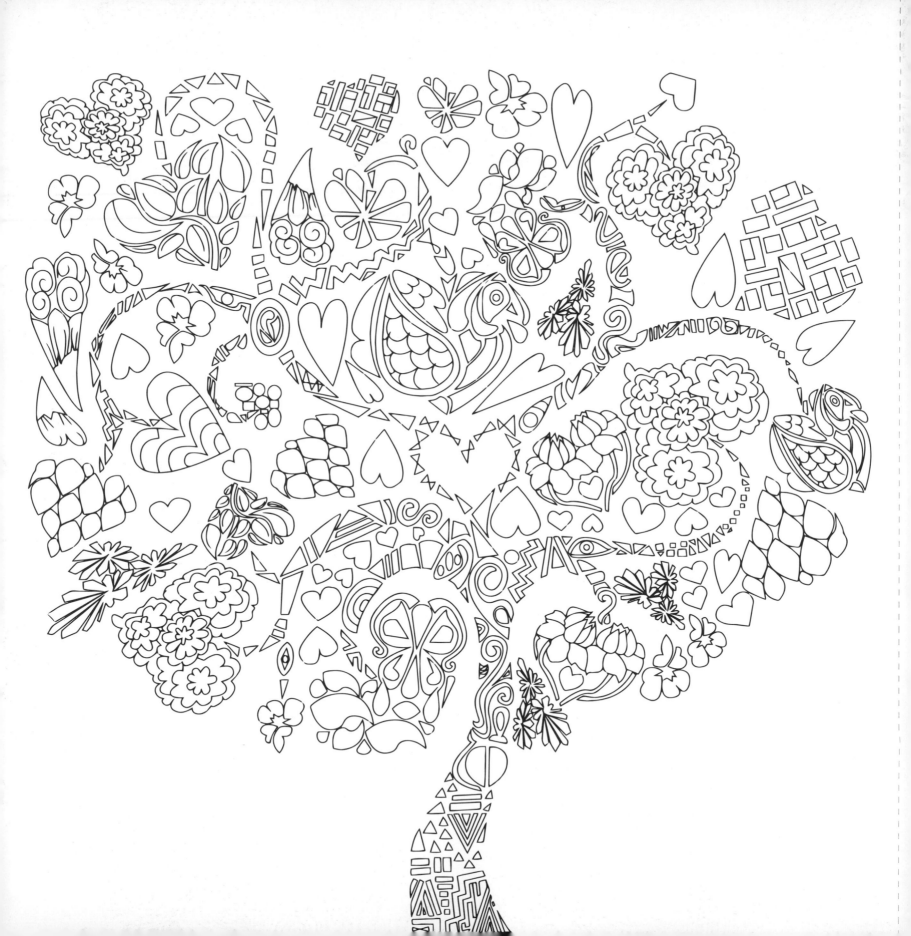

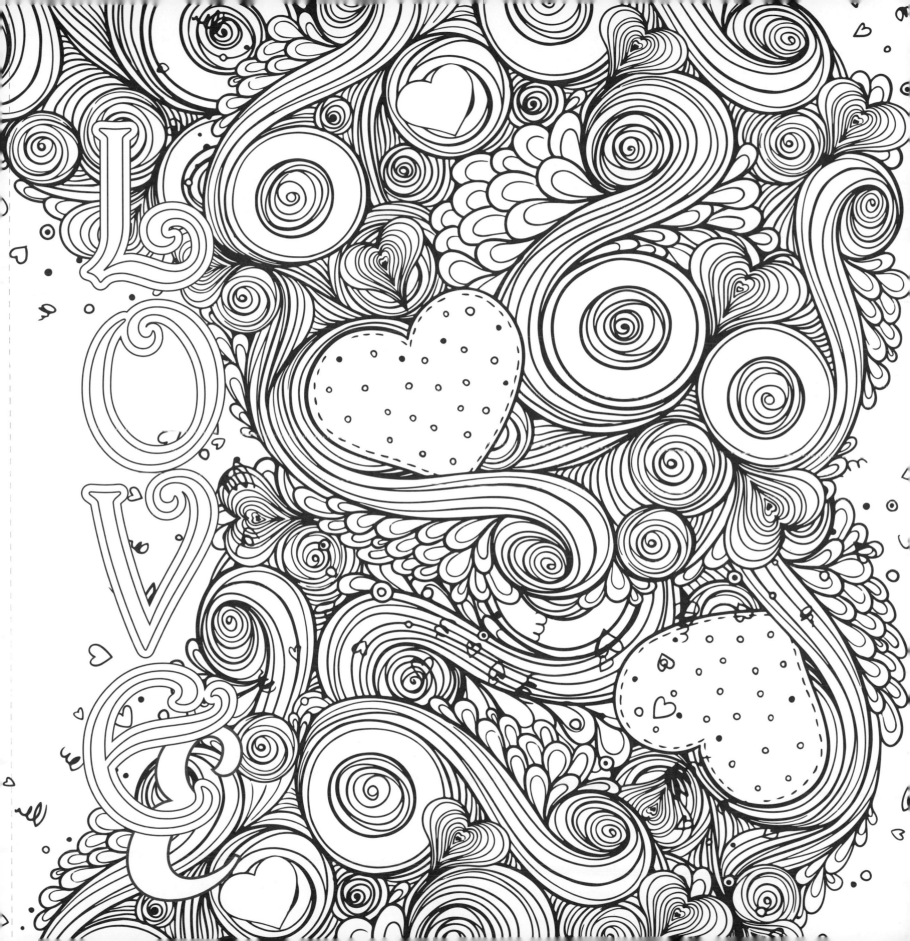

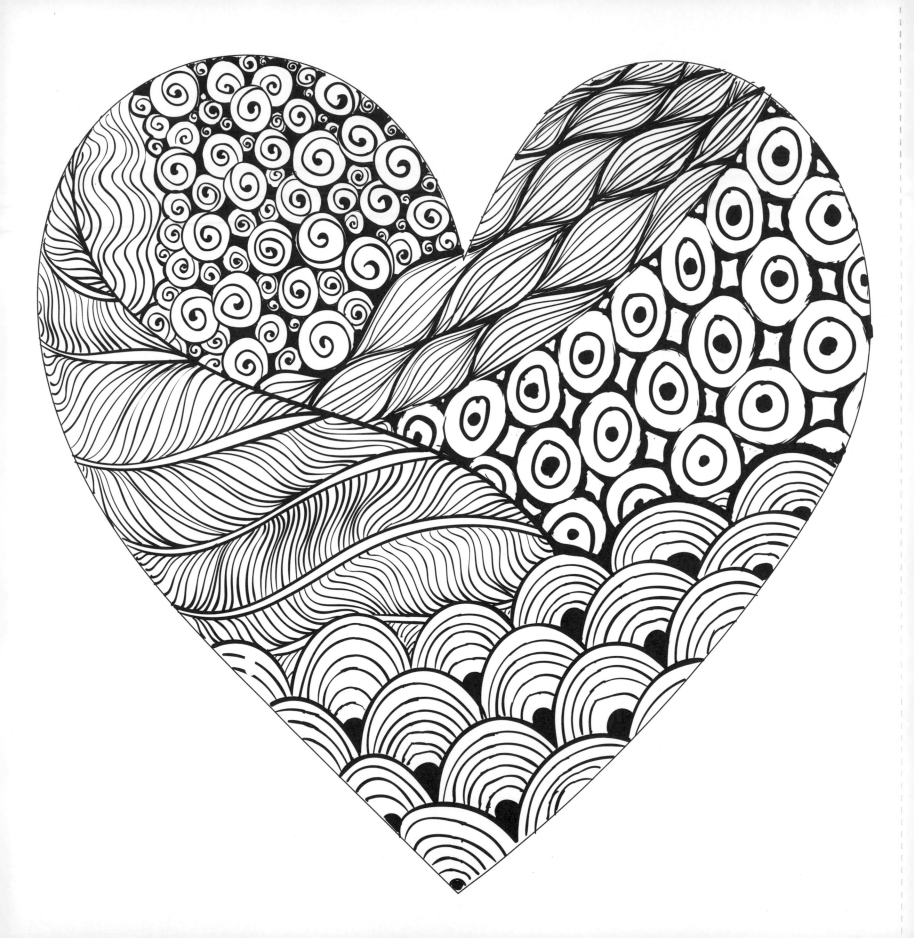

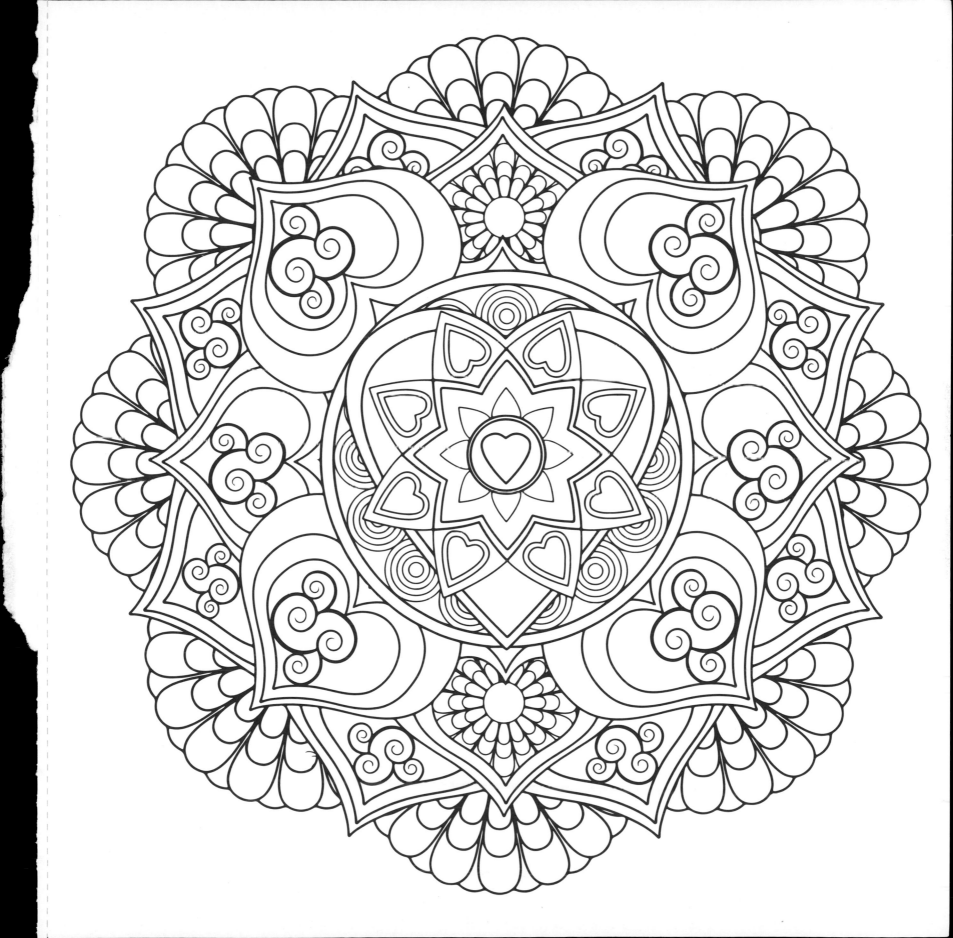

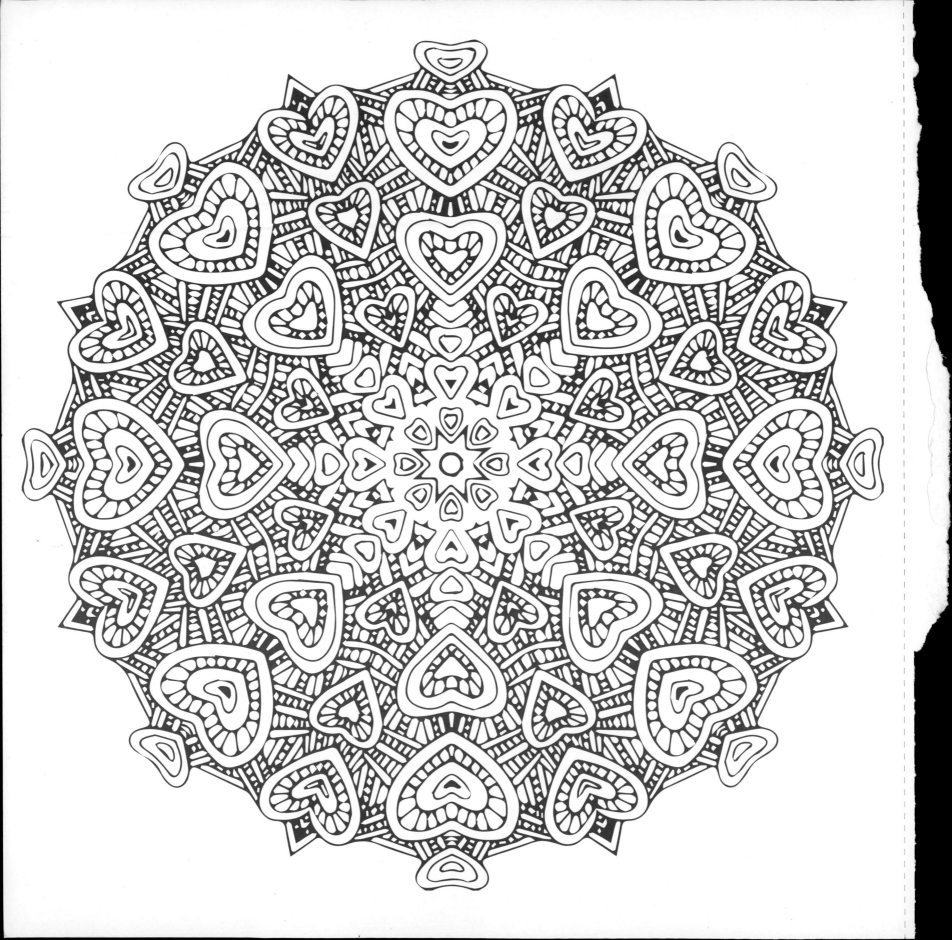